II0955408

Helpful Hints for Housewives

A Treasury of Tips for the Modern Homemaker

Benjamin Darling

Helpful Hints for Housewives

A Treasury of Tips for the Modern Homemaker

Benjamin Darling

CHRONICLE BOOKS • SAN FRANCISCO

Copyright © 1992 by The Blue Lantern Studio. All rights reserved. No part of this
book may be reproduced in any form without written permission of the publisher.

Printed in Singapore.

ISBN: 0-8118-0006-7

Library of Congress Cataloging in Publication Data available

Distributed in Canada by Raincoast Book
112 East Third Avenue,
Vancouver, B. C., V5T 1C8

10 9 8 7 6 5 4 3 2 1

Chronicle Books
275 Fifth Street
San Francisco, California 94103

Introduction

These helpful hints are culled, for the most part, from promotional pamphlets of the first half of this century; they are drawn from the promotional pamphlets of refrigerator companies, lemon-growing associations and spice manufacturers, among others. These institutions offered helpful suggestions to ensure the proper use of their products, knowing that efficient use prevented frustrated consumer complaints.

Many pamphlets assured us that their product or appliance would end kitchen drudgery and ensure family happiness. For example: "When you add a Leonard to your kitchen assets, you turn dreams of more ideal living into active possibilities." We also discovered what fun cooking could be: "Congratulations! You're about to start on a wonderful new cooking career—deep fat frying."

Although the ingeniousness and inventiveness of the ephemeral promotional pamphlet seems to have waned in recent decades, we are the grateful inheritors of a wealth of material. I have selected the hints in this book for their graphic rightness, or their arcaneness—anything that appealed and could be broadly defined as a helpful hint. While I might recommend that this book is more to be enjoyed as a scrapbook than as a tool, it is possible that you might accidentally stumble across something truly useful herein. It is loosely grouped into three categories, the first section being food hints, the second entertaining hints, and the third hints that didn't fit into either of the first two categories. Armed with this knowledge you should be able to navigate this book with the same ease and enjoyment you would have had had you not read this introduction at all.

A final note: I have compiled another book along similar lines to this one (actually it's a little better than this one) entitled *Cakes Men Like.* I recommend that you buy it.

—Benjamin Darling

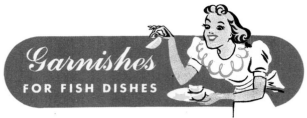

Garnishes
FOR FISH DISHES

NOTHING peps-up the appetite more than an eye entrancing platter of perfectly cooked fish beautifully garnished . . . and no other food lends itself so completely to attractive garnishes than fish cooked to a luscious golden brown.

Hard-cooked Eggs, sliced and sprinkled with paprika add to the appearance of any fish dish. Use devilled, cut into wedges and decorate with parsley or narrow strips of pimiento. Minced egg can be sprinkled over most creamed fish dishes.

Green Pepper, cut across or in strips add much with their dark color.

Lemons, always use with fish or seafood dishes except when creamed. Cut in quarters, slices or wedges. Sprinkle with parsley, paprika or finely chopped pimiento. Or, carve into baskets with handles and fill with tartar sauce. Or, cut into fancy shapes, with slices that have part of the peel curled.

Curly Endive, is specially effective because of its range of color from yellow green to dark green.

Lettuce, is always the standby as a basic garnishment.

Parsley and Watercress, both make a beautiful garnish for fish.

Cucumbers, slice, leaving peeling on for appearance or run tines of fork down lengthwise to score then slice. Make cups from the ends of unpeeled cucumbers by scooping out pulp then cut petals down almost to base. Drop into iced water which will make petals open. Trim flat on bottom. Fill with tartar sauce or mayonnaise.

Pimientos, can be cut into the shape of diamonds, clubs, etc., or sliced thin and added to other garnishes have a place all their own in the realm of garnishes.

Celery tops, with leaves give a note that is different.

Bacon, shouldn't be overlooked when serving trout or other game fishes and can be used with fried fillets.

Beets, small whole pickled beets or sliced and cut into fancy shapes always are delicious as well as attractive.

Radishes, made into roses or tulips dress-up any dish.

TABLE OF
Fish Cookery

All fish are delicious but most are better when prepared in a manner that brings out all their finest flavors. In the table "BEST" indicates the method of cooking recommended for the fullest enjoyment of each variety of fish.

Variety		Deep Fry	Pan Fry or Saute	Broil	Bake	Boil
Bass	Lean	Good	Best		Good	
Blufish	Lean	Good	Good	Good	Best	
Blue Pike	Lean		Best	Good	Good	
Buffalo	Fat		Best	Good	Good	
Catfish	Fat	Good	Best			
Cisco	Fat		Best	Good		
Cod	Lean	Good	Good	Good	Good	Best
Crappie	Lean	Good	Best	Good		
Flounder	Lean	Good	Best	Good	Good	
Grouper	Lean				Best	Good
Haddock	Lean	Good	Good		Good	Best
Hake	Lean				Best	Good
Halibut	Lean	Good	Good	Best	Good	Good
Herring	Fat	Good	Good	Best	Good	Good
Lake Trout	Fat	Good	Good	Good	Best	Good
Lingcod	Fat				Best	Good
Mackeral (Boston)	Fat			Best	Good	Good
Mackeral (Florida)	Fat		Good	Best	Good	
Perch	Lean		Best	Good	Good	
Pollock	Lean			Good	Good	Best
Pompano	Fat		Good	Best	Good	
Red Snapper	Lean			Good	Best	Good
Sablefish	Fat			Good	Best	Good
Salmon	Fat			Good	Best	Good
Shad	Lean			Good	Best	
Smelt	Fat		Best	Good	Good	
Sole	Lean	Best	Best	Good		
Swordfish	Lean			Best	Good	
White Bass	Lean	Good	Best	Good		
Whitefish	Fat		Good	Good	Best	
Whiting	Lean		Best	Good	Good	
Yellow Pike	Lean		Good	Good	Best	Good

7

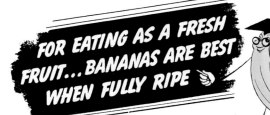

FOR EATING AS A FRESH FRUIT... BANANAS ARE BEST WHEN FULLY RIPE

BANANAS ARE FULLY RIPE WHEN FLECKED WITH BROWN

If the bananas you buy in the store have green tips like this... or are all yellow like this... let them ripen in a bowl until like this... they have brown flecks like this...

STOP

DO NOT STORE IN REFRIGERATOR— COLD TEMPERATURES PREVENT PROPER RIPENING.

SUIT THE *Color*
TO THE *Use*

TIPPED WITH GREEN?

The banana is partially ripe. The pulp is firm, starchy, slightly tart. Just ready to bake or broil or fry—cooking brings out a different, delicious flavor.

ALL YELLOW?

Now it's ready to eat or cook and can be used as an ingredient in baking.

FLECKED WITH BROWN?

Now it's fully ripe, at its best for eating, infant feeding and as an ingredient in baking. It's sweet, mellow, thoroughly digestible and downright delicious in fruit cups, salads, milk shakes and desserts.

GRAPEFRUIT TIPS

Easy to Peel

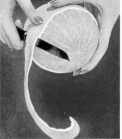

SUNKIST GRAPEFRUIT IN THE MENU

Sunkist grapefruit, grown only in California and Arizona, is rightly popular with those who plan menus to include fresh fruit for health every day. It deserves this popularity because of its true fresh fruit flavor, year 'round availability, and uniformly high quality, guaranteed by the name "Sunkist," stamped on skin or wrapper. It fits into the menu, moreover in many novel and healthful ways—the breakfast glass of fresh juice, luncheon and dinner appetizers, salads and desserts. Sunkist grapefruit is practically seedless.

Easy to Segment

TO SEGMENT SUNKIST GRAPEFRUIT

Sunkist grapefruit has a firm, juice-retaining meat, practically free from seeds and easy to prepare in the *fresh* segments, which give distinctive flavor to dishes, made with it.

Segments: With a sharp knife, peel down to juicy meat, removing all outer skin and membrane. Cut on either side of each dividing membrane and remove meat, segment by segment as shown.

Pieces: When segments are too large for recipe use, cut them in pieces.

Note: Save any escaping juice and use for salad dressings and marinades.

Easy to lift out

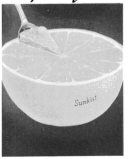

SUNKIST GRAPEFRUIT HALF SHELL

Quickest and simplest of first course appetizers, is a halved Sunkist grapefruit. One operation with the knife cuts fruit in halves, ready to serve. Segments lift out easily with a spoon. If desired, loosen with a sharp knife or scissors.

A maraschino or mint cherry or a mint sprig attractively garnishes center. Sweeten with sugar, honey or maple syrup. With smaller sized fruit, it is smart to serve two halves for one portion (see illustration on back cover).

AVOCADO HINTS

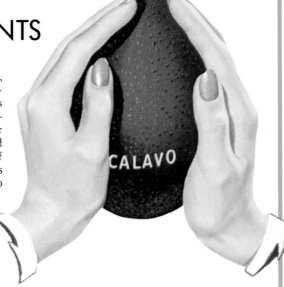

CALAVO stands for highest quality, careful selection, grading and packing...your assurance each fruit has met exacting standards for taste-appeal and all-around goodness. For your protection, CALAVO is stamped only on the best fruits of 14 out of 99 commercial avocado varieties grown in California. *Buy* CALAVO *and be sure.*

BUY "SOFT"...To serve the same day.

BUY "FIRM"...To serve in two or three days. Keep in a cool place, but not below 40°. Firm avocados will soften normally at room temperature...above 80° they soften rapidly.

When Calavos are ready to serve...Like many other fruits, Calavos are firm when picked, and soften later. To tell when at its "eating best," hold fruit between cupped hands and press gently. If it "gives," feels soft, it is ready to serve.

Preparation... It is desirable to prepare Calavos just before serving. As with other fruits, the cut surface sometimes darkens slightly after exposure to the air. This does not affect flavor or taste. To preserve the bright, fresh-cut color, sprinkle with lime or lemon juice. Any portion to be held for serving later should also be wrapped in waxed paper before placing into refrigerator. A darkened surface may be easily removed by scraping lightly with knife.

First rules of the kitchen road

Of course you want to do things your own way! We all do...and the kitchen *is* a one-woman domain. But if you watch the smart homemaker set about her cooking you'll find she...

PUTS on an apron as she goes into the kitchen.

GETS all the ingredients together before beginning to prepare any recipe. And this *really* saves time and steps when there's a dinner to prepare.

CLEANS up after *each part* of the meal is finished, instead of facing a LARGE mound of soiled utensils at dishwashing time!

Even dishwashing needn't be dull!

Use a tray to remove soiled plates, glasses and silver from the table. But do avoid a crash at the swinging door!

Rinse glasses and silver. Scrape, rinse and stack china.

Place leftovers in covered bowls and place warm water in pans that are heavily soiled.

Wash glasses and silver first, then dry them. If you are using detergent suds, the plates, cups, saucers and other china may be washed and allowed to drain dry.

TIME SCHEDULE *for cooking vegetables direct or indirect*

Artichokes	25-40 minutes		Fennel	20-40 minutes
Asparagus	15-30 minutes		Greens	25-40 minutes
String Beans	30-45 minutes		Kale	25-30 minutes
Lima Beans	30-45 minutes		Kohl-rabi	25-40 minutes
Beets, young	40-50 minutes		Leeks	15-20 minutes
Beets, old	3-4 hours		Lentils	3-4 hours
Broccoli	15-30 minutes		Okra	20-30 minutes
Brussels Sprouts	15-25 minutes		Onions	25-45 minutes
Cabbage	15-25 minutes		Oyster-plant	45-60 minutes
Carrots, young, whole	20-25 minutes		Parsnips	30-45 minutes
Carrots, old, sliced	25-30 minutes		Peas	15-25 minutes
Cauliflower	10-15 minutes		Potatoes	30-40 minutes
Celeriac	15-20 minutes		Pepper, green	5 minutes
Celery	20-35 minutes		Radishes	20 minutes
Chayote	20-30 minutes		Spinach	10-15 minutes
Corn, green	15-18 minutes		Salsify	45-60 minutes
Cucumbers	10-15 minutes		Squash, Summer	15-20 minutes
Chard, Swiss	25-30 minutes		Squash, Winter	25-30 minutes
Dasheens	25-35 minutes		Turnips	20-25 minutes
Eggplant	15-20 minutes		Tomatoes	15-20 minutes
Endive	10-12 minutes			

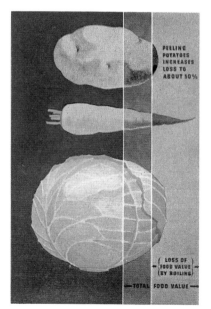

PEELING POTATOES INCREASES LOSS TO ABOUT 50%

LOSS OF FOOD VALUE (BY BOILING)

TOTAL FOOD VALUE

POTATOES

● There is a 10 to 15% loss of soluble mineral content by boiling potatoes in skins. Peeling them, then boiling, increases the loss to about 50%. (See illustration).

CARROTS

● In the case of carrots, there is a loss of 20 to 30% of soluble mineral content by boiling. Cooking the New Method Way saves a large part of the valuable mineral salts. (See illustration).

CABBAGE

● Boiling cabbage causes it to lose from 30 to 40% of the mineral salts. Aside from better flavor which pleases both children and adults, the New Method is a more healthful way of cooking! (See illustration).

13

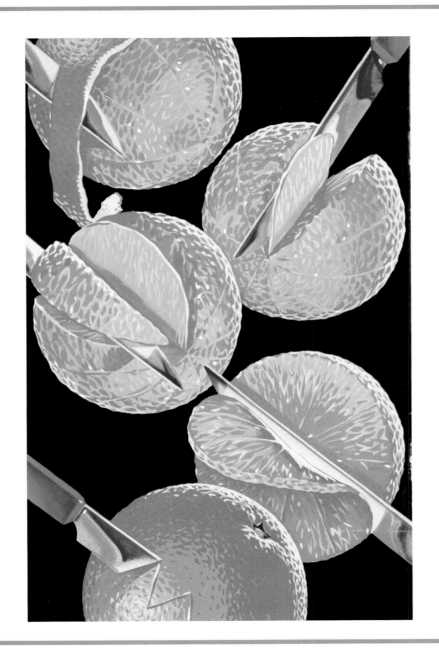

Fresh from California

These recipes come to you from the Sunkist kitchen, where they have been carefully tested to make certain that they will give complete satisfaction. Sunkist oranges are available every day in the year, fresh from California's finest groves.

PREPARING SUNKIST ORANGES FOR TABLE USE

Freshly extracted Sunkist orange juice is one of the most popular and healthful of beverages. An 8-ounce glass is an important breakfast rule.

Sunkist oranges also have special value for fruit cups, salads and desserts. In addition to excellence of flavor they are practically free from seeds and of firm texture, easy to prepare in the slices and sections used for these dishes. For sections and slices, large and medium sizes are best. Smaller sizes are usually "best buys" for juice purposes.

TO PEEL: In the preparation of oranges for salads and desserts, use a sharp, stainless knife. Remove all outer peel and membrane; cut right down to the juicy sections as shown in upper left illustration.

SECTIONS: To obtain perfect sections free of membrane cut down on either side of the dividing membranes of the peeled oranges. This releases each individual section as shown.

SLICES: Thick or thin slices are easily cut from the smoothly peeled oranges.

PIECES: Cut sections or slices in pieces.

ORANGE CUPS: Fluted orange cups are simply made. The sharp knife is the only tool necessary. Pierce knife to center of unpeeled orange with zigzag strokes which meet to make points of the scallops, as illustrated. Separate the two orange halves and remove the juicy sections. See finished cup on page 24.

GRATED PEEL: For grating orange peel use a grater with holes about ⅛ inch in diameter, and about ¼ inch apart. When this shredder-type grater is used, and only the outer, orange-colored layer of the orange, which contains the oils that give flavor, is removed, the resulting grated peel is in the form of fluffy, orange flakes. This is preferred for flavor and economy to commercially prepared extracts. Grated peel is used to flavor cakes, pies, breads, desserts, frostings, fillings and sauces. Sunkist oranges have clean skins of waxy texture best suited for this use.

Toast Talk

"Toast" Points

- Toasting converts some of the starch of bread into simpler carbohydrates and removes some of the moisture. Attractive, crunchy hot toast has the same caloric value as untoasted bread —60 calories per one-half inch slice.

- For the best toast, use bread at least 24 hours old, and serve it piping hot.

- Frozen bread slices may be put into the toaster for immediate toasting. They require a few extra seconds toasting time.

- Hot toast should never be stacked. If it must be held for a few minutes, arrange toast slices on a rack and place in a warm oven until served.

- For distinctive toast service, arrange triangular slices of toast on a folded napkin on a hot plate, slightly over-lapping them. The napkin will absorb the steam from the hot toast and keep it crisp.

- Trim edges of bread after toasting. Cut into desired shapes. Cookie cutters can be used to fashion the base for canapés or to dress up casserole dishes.

- Cube leftover toast to make croutons for soups and salads.

Keep plenty of inexpensive packaged bread on hand for wholesome "between meal" snacks that please all ages!

16

Entertain often! "Toast Cookery" lets you make a big impression for just a little money!

Men take to "Toast Cookery" . . . it's the easy way to rate high as an amateur chef!

"TOAST" . . . FOR A
GOOD BREAKFAST

Sandwich Suggestions

Picnics

★ Picnic Sandwich Suggestions

COTTAGE cheese makes a delicious sandwich filling. For sandwiches, moisten the cheese with sweet cream, flavor with a little chopped parsley, chopped or sliced olives, sliced celery, pimientos, horseradish, Spanish onions, nuts or pickles. Other picnic sandwich combinations follow:

> Boiled ham with cottage cheese and chopped sweet pickles.

Hard-cooked eggs, chopped and mixed with mayonnaise and minced bacon.
Cream cheese, ripe olives, and nuts.
Butter mixed with honey.
Smoked fish, carefully picked over to remove all bones.
Chopped raisins, with nuts and lemon juice to season.

★ Some Favorite Fillings for any kind of Sandwich

Deviled ham, pickle and mayonnaise.
Minced corn beef and horseradish.
Sardine paste with lemon juice and parsley.
Peanut butter and chow chow.
Beef, veal, ham or lamb loaf with Russian dressing.
Grated raw cabbage and bacon mixed with sandwich spread.
Mashed liverwurst with mayonnaise.

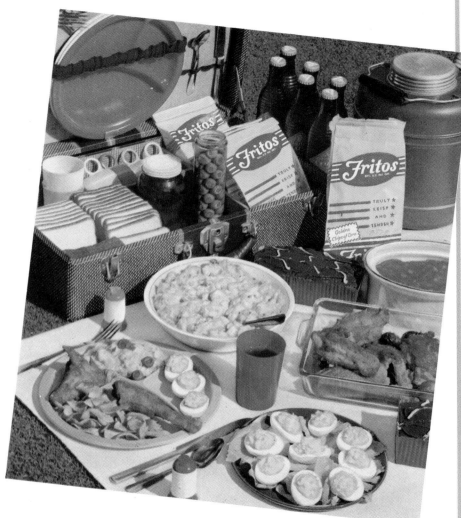

★ Open Faced

WATERCRESS—Pick over, wash, drain and chop fine, one bunch water-cress, about one-half cup, and mix with softened cream cheese. Spread on large rounds of bread. Encircle with Fritos.

CUCUMBER—Pare medium cucumber, cut lengthwise, extract seeds and chop. Season with grated onion and mix, if preferred, four hard cooked eggs, chopped fine. Spread on large rounds of bread. Serve with Fritos.

vogue in salads

every salad has its place

The salad may play one of many important roles in the drama of dining. It may be the curtain raiser of the meal, incidental to a hearty dinner, and in this guise is quite a different affair from the salad served as the main dish of a luncheon or supper. And again each of these is foreign to the dainty creation served as dessert.

simple salads for a hearty dinner

THESE are often little more than the crisp green salad plants—lettuce, romaine or endive—or a light vegetable salad or those containing a little tart fruit. They must not be too heavy.

When served with the meat, the salad, already dressed, is placed at the left of the dinner plate. In this case, the salad is eaten with the dinner fork, just like another vegetable.

When the salad is a course by itself at dinner, everything pertaining to the meat service is removed from the table. The individual salad plate is then placed directly in front of each person. It may contain the salad, or each diner may help himself from the bowl.

Another attractive custom is to place the ''capacious salad bowl'' before the hostess who serves the salad on the individual plates, borrowing the dainty formality of the French, where salad service is a ceremonial rite.

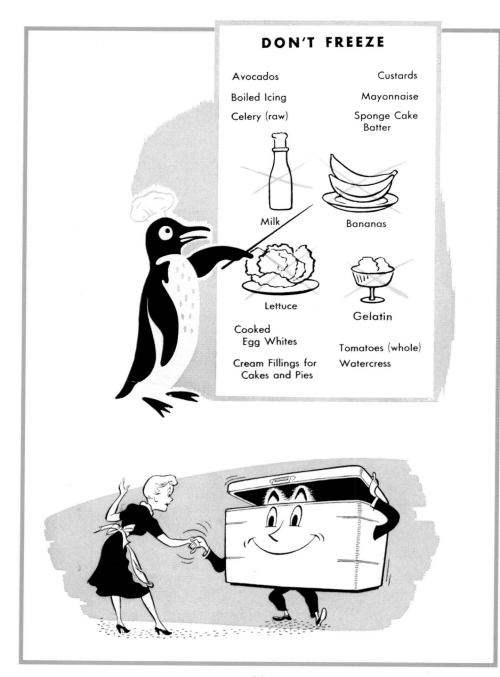

DON'T FREEZE

Avocados

Boiled Icing

Celery (raw)

Milk

Lettuce

Cooked
Egg Whites

Cream Fillings for
Cakes and Pies

Custards

Mayonnaise

Sponge Cake
Batter

Bananas

Gelatin

Tomatoes (whole)

Watercress

FREEZING HINTS

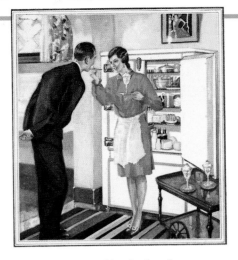

1. In choosing fruits and vegetables for freezing, select varieties which will yield frozen products of high quality. *Freezing will not improve low-grade foods!*

2. Remember that slightly immature vegetables and fruits are much better than those which are old and starchy.

3. Prepare vegetables and fruits for freezing *immediately after harvest!* If this is not possible, store them in a refrigerator—but not for more than eight hours.

4. Sort, clean, and wash vegetables and fruits in cold running water or ice water.

5. Scald vegetables for the proper period. (If you live 5,000 or more feet above sea level, scald for one minute longer than indicated in charts.) Vegetables should be scalded in small amounts, about one pound at a time.

6. Chill vegetables to 50° F, using an ample supply of cold running water or ice water.

7. Drain and package vegetables and fruits immediately in moisture-vaporproof packages. Food expands as it freezes. Therefore, leave about one-half inch head space for foods that pack tightly—three-quarters of an inch for foods packed in liquid, purees, or crushed fruits. No head space is needed for loosely packed foods, such as broccoli or cauliflower.

8. Place packages against the side walls of the freezing cabinet, or on the utility shelf if your freezer has one. Do not stack warm packages on top of one another.

How to give your refrigerator the best of care

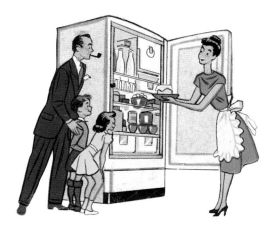

Simple things you can do
—to get better refrigeration
—to save money on current and upkeep
—to prolong the life of your refrigerator

Let hot dishes cool before putting them in the refrigerator. Placing hot foods in your refrigerator may raise the temperature of the food compartment. And it wastes current, too. To cool foods quickly before storing in refrigerator, leave them in pan and immerse in a larger pan of ice or cold running water.

When desserts are not being held, return the control to normal.

Turn control to warmest setting ("Vacation setting") when going away for several days. This saves current.

Avoid frequent and lengthy door openings. They naturally waste current and raise the temperature in your refrigerator. This makes your refrigerator work harder. What's more, in hot, humid weather, it builds up frost on the freezer faster and this means you must defrost oftener.

Do not freeze more ice cubes than you need because you can use this extra freezer space for making frozen desserts, for freezing meats or for storing frozen foods.

Do not store foods in your refrigerator which do not need refrigeration. It wastes storage space.

Immediately wash off foods and liquids spilled on the inside or outside of your refrigerator. For example, lactic acid in milk will stain even the best enamel and porcelain finishes in time.

KITCHEN WEIGHTS AND MEASUREMENTS

4 gills equal 1 pint
2 pints equal 1 quart
4 quarts equal 1 gallon
16 ounces equal 1 pound
$\frac{1}{2}$ measuring cup equals 1 gill
2 measuring cups equal 1 pint
4 measuring cups equals 1 quart
2 tablespoons equal $\frac{1}{8}$ cup
4 tablespoons equal $\frac{1}{4}$ cup
5 1-3 tablespoons equal 1-3 cup
8 tablespoons equal $\frac{1}{2}$ cup
10 2-3 tablespoons equal 2-3 cup
12 tablespoons equal $\frac{3}{4}$ cup
16 tablespoons equal 1 cup
2 tablespoons sugar weigh 1 ounce
2 tablespoons butter weigh 1 ounce
 Butter size of an egg should measure 4
 tablespoons
2 cups butter weigh 1 pound
2 cups granulated sugar weigh 1 pound
2 2-3 cups powdered sugar weigh 1 pound
2 2-3 cups brown sugar weigh 1 pound
$3\frac{1}{2}$ cups confectioners' sugar weigh 1
 pound
4 cups pastry flour weigh 1 pound

Culinary Terms

AU GRATIN—A dish covered with sauce and browned in the oven.

BLANCH—To put into cold water and bring to the boil—to remove skins from nuts, etc.

BOUQUET GARNI—Bunch of herbs, usually parsley, bay leaf, thyme or marjoram.

CROQUETTE—Mince of fish or meat, made into various shapes and coated and fried.

CROÙTONS—Small dice of fried bread.

MACEDOINE—A mixture of various fruits or vegetables cut in fancy shapes.

MIREPOIX—Foundation or bed of vegetables used in preparing braised food.

PANADA—Mixture for binding ingredients used as a foundation for mixture of soufflé type.

PURÉE—Vegetables and fruit, etc., reduced to a pulp by cooking and sieving.

RECHAUFFÉ—Any dish made with re-heated food.

RISSOLES—Mixture similar to that of croquettes.

ZEST—The rind of a lemon or orange pared thinly without any pith.

SPICES AND FLAVORS

PEPPER, WHITE—Practically the same as black pepper except that the outer shell or pericarp of the berry is removed. Used where color of black pepper is undesirable.

CELERY—Every part of the plant can be used to advantage. Stalks and heart may be used raw, plain or with various fillings. Outer stalks may be stewed, scalloped, and in combination to give flavor to other vegetables such as potatoes. Trimmings may be used for flavoring soups or in any cooked meat or vegetable dishes. Dried seeds may be used in pickles and to flavor soups and salads.

CHIVES—Leaves are used in many ways. May be used in salad, in cream cheese, in sandwiches, omelettes, soups, and in fish dishes. Mild flavor of onion.

GARLIC—Vegetable similar to a small onion but with the bulb divided into sections known as cloves. May be used in very small amounts in flavoring meats, soups, sauces, salads, pickles.

28

SPICES AND FLAVORS

TARRAGON—Leaves have a hot, pungent taste. Valuable to use in all salads and sauces. Excellent in Tartar sauce. Leaves are pickled with gherkins. Used to flavor vinegar.

SWEET BASIL—Distinct flavor of cloves. May be used for flavoring salads, soups and meats.

ALLSPICE—Sold whole or ground. Better combined with other spices in fruit dishes, cakes, pies, pickles, etc.

CARAWAY—Seeds have a spicy smell and aromatic taste. Used in baked fruit, in cakes, breads, soups, cheese and sauerkraut.

CAYENNE PEPPER—Usually obtained from small fruited varieties of capsicum. It should be of dull red color. May be used in very small amounts in vegetables and in some salad dressings and in cheese dishes. It must be used with care, however, and paprika is successfully substituted.

CLOVES—Should be dark brown in color. Usually used in combination with other spices, which gives a better flavor than cloves used alone. Too much, gives an undesirable color as well as a bitter flavor.

CURRY POWDER—A number of spices combined in proper proportion to give a distinct flavor to such dishes as vegetables of all kinds, meats, poultry and fish.

MACE—The inner envelope of nutmegs. May be used both in "blade" and ground form in soups, sauces, pastry, pickles.

MUSTARD—Young tender leaves are used for greens and for salad. Seeds are used as a ground spice in salad dressings, pickles, sauces, in some vegetable cookery, and in some cheese dishes. Made into a paste and served with meats.

NUTMEG—Sold whole or ground. Gives good flavor, used alone in small amounts, in various soups, meat dishes, pastry and in all dough mixtures. In combination with other spices for pickles.

PAPRIKA—A Hungarian red pepper. Bright red in color. May be used in all meat and vegetable salads. In soups, both cream and stock, as a garnish for potatoes, cream cheese, fruit salads or eggs.

PEPPER, BLACK—Reduced to proper fineness by grinding and sieving. Used in all meat and vegetable dishes where the color does not affect the product.

PEPPERCORN—The whole berry of the pepper plant.

Cooking with Wine

There was a time in the dark ages (B.C.)*when cooking with wine was veiled in mystery

. . . people said you had to have exotic ingredients . . . and a wine cellar so vast it reached from

here → to there →

. . . but that isn't so! Thousands of women (and men, too) have now discovered that cooking with wine is no more complicated than cooking with salt and pepper.

*Before Commonsense

30

In many cases you don't even need a recipe. When you add your other seasonings, pour in a little wine as well.

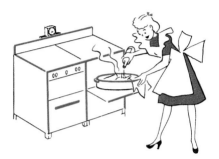

Your taste will tell you How Much

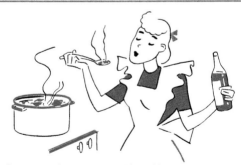

And your family will tell you

How Good!

The casual *California Way*

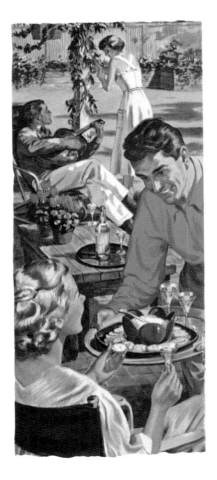

UNEXPECTED GUESTS are no problem — when you welcome them the casual *California way*. For there's no need to fuss . . . there's no need to bother. In fact, the less fretting you do, the more fun your guests have. For casual guests don't expect elaborate refreshments. And they really feel more welcome, more at ease, when you don't wear yourself out trying to whip up something fancy and add a lot of frills.

So keep these "impromptu" occasions as informal and natural as possible. Serve simple things like those suggested here. Then to add a sparkle — and a dash of glamour — serve your guests a bright, gay wine. Wine itself is something that rises to the occasion when you have drop-in visitors. For instance, with a bottle of Sherry in the cooler or refrigerator, or a bottle of Port on hand, you need only bring out the wine, open it and pour good glassfuls for everyone.

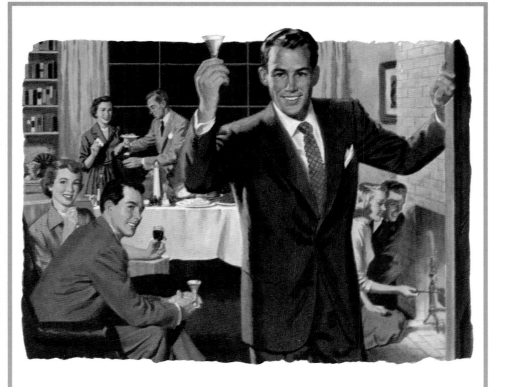

How to Serve Sparkling Wines

Champagne, Sparkling Burgundy and other sparkling wines should be served very well chilled. They may be chilled by placing in the refrigerator for several hours or in the traditional champagne bucket filled with cracked ice.

To open a bottle of sparkling wine, wrap a napkin around it and twist the wire that holds the cork in place. Remove tinfoil and wipe off neck of bottle with clean cloth. Hold the bottle at an angle in the left hand and with right hand ease out the cork. Be sure to hold palm of the hand over the cork so it won't fly out.

WINE IS FUN

First... let's get this straight.
Wine is usually served in glass...

but it
can be
any
glass!

What's the difference between
wine glasses and a tumbler?

None... Wine tastes the same from any
glass. If you have wine glasses, they're fun
to use, and pretty, too.

and second...

keep this in mind, too.
Wines...table wines especially
...are usually served with food

"Red wines with
red meats"*

"White wines with
chicken or fish"

But in spite of the "experts,"

you can serve
almost <u>any</u> <u>wine</u>
with
almost any food!

*Most people think red meats taste better with the red table
wines. And they actually do. That's because of a taste harmony
between red meats and red table wines. There's also a taste har-
mony between white wines and fish. But some people like other
wines with meat and fish. So why not suit yourself?

Breakfast

THIS is the most important meal of the day, and, instead of being a hurried scramble, it should be served daintily and harmoniously. One of our worst national faults is that of the hasty, inadequate breakfast. Every one needs a substantial meal to start the day, and if it is served with a reasonable amount of leisure and in a happy atmosphere, it will go farther toward making business men efficient, children well nourished and consequently progressive at school, and the mother in the home happy and radiant, than any other one thing.

For breakfast the same general rules of table-setting prevail as described previously.

If desired, the flowers or fernery usually kept in the center of the table may be replaced by a bountiful dish of fruit, but it is a better plan to have the fruit apportioned for each person. If it demands a fruit knife, the latter may be laid across the edge of the fruit plate for service without a maid, or at the extreme right for service with a maid. When a maid is in attendance finger bowls should be placed at the right of each person just before the fruit course is finished.

Coffee is generally poured at the table, the cream and sugar, and tile for the pot, together with the cups and saucers, being at the right of the hostess. Coffee is served with the main course.

The table should be at its very prettiest — linens with colored embroidery echoing the dining-room decorations, and attractive dishes in cool greens or soft yellows lending cheer. In winter, if possible, have a bit of a fire, and, *above all*, have the room in order.

The menu should be substantial ; if children are in the family, a cooked whole-grain cereal, and milk or cocoa as a beverage, should always be provided.

How About Your Table?

Even the simplest meal seems to taste better if the table is attractive. Dishes and glassware need not be expensive. Very dainty ones can be purchased at the 5 and 10 Cent Store. Buy several sets in different colors for variety. Colored cloths and napkins are popular now, especially in the small luncheon and breakfast sizes. They launder easily and make the table look bright and cheerful. A few flowers in the center of the table are nice. Keep them low. It is a very annoying to have to talk across the table *through* the centerpiece.

Above all, keep the table clean and neat. Let your dishes be immaculate, your silver shining, your glass sparkling and your linen spotless. A table should never look as if everything had been "thrown" on it. Keep the knives, forks and spoons *straight* and the dishes orderly.

Place the knife at the right of the plate with the sharp edge toward the plate. Fork at the left of the plate, tines up. Teaspoon beyond the knife. If several spoons and more than one knife and fork are needed for the meal, place them in the order they will be used, working *toward* the plate.

The bread and butter plate goes at the left, beyond and above the fork. Water glass at the right, above the knife.

If hot meat is to be served, warm the plates.

Before serving dessert, remove all used dishes and silver. Brush the crumbs from the table cloth.

THE CALIFORNIA BARBECUE
Out in the open—
out of this world!

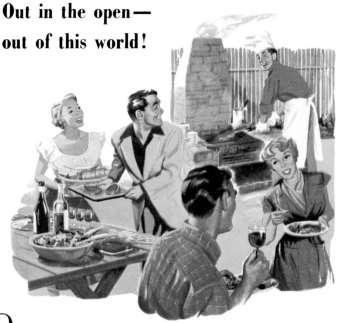

Dining "AL FRESCO" is part and parcel of the California way. Wherever a barbecue grill can be built or a portable one set up—in the garden, patio, or back yard—people like to get together, grill steaks and chops and enjoy a leisurely, informal outdoor meal. It's a grand way to handle a crowd!

Much of the preparation can be done ahead of time. The barbecue sauce can be made a day or so before . . . most casserole dishes can be made in the morning and reheated just before dinner. The French bread can be spread with butter, cheese, or whatever, several hours ahead of time and wrapped snugly in waxed paper to await toasting.

Favored seasonings for barbecue foods are California wines, herbs and garlic. Wine is used to marinate meats and fowl before cooking and to flavor the barbecue sauces for basting. Herbs and garlic give individual seasoning to barbecued meats and salad dressings. Along with the barbecue meal California hostesses like to serve wine.

Let's Eat Outdoors

Because charcoal briquets ignite first in small areas you may think the briquets are not burning. But look closely and you will see tiny gray spots which show where the briquets are burning. To prove to yourself that these gray areas are actually burning, pick up a briquet with a pair of tongs, blow on it and you will see a red glow.

As the briquets burn, a deposit of fine gray ash is left on the surface of the coals. The heat is released through the ash in the form of infra-red rays. In the daytime, the red glow is not normally visible, but when barbecuing with a hood it is sometimes possible to see the glow. At night the red glow is visible.

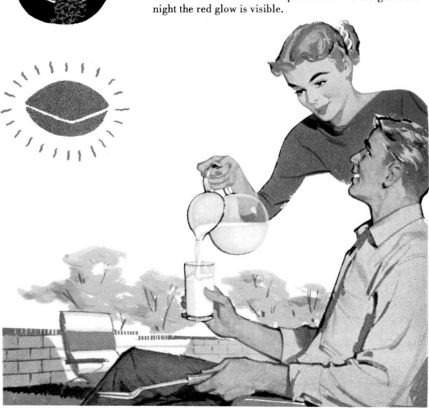

PREPAREDNESS MAKES DOING EASY

The great majority of the American housewives do their own work.

A bit of hourly help now and then is the extent of help in thousands of representative homes.

To be able to prepare a perfect meal, have the house in order, the children happy and spotless, the table attractively set, and to serve the meal oneself at the same time retaining one's poise, occupying the hostess' place at the table, directing the conversation and creating a feeling of true hospitality is, perhaps, the greatest test of one's generalship.

These suggestions will help make the accomplishments a pleasure.

The "Day Before"

1. Plan menu and do all buying excepting fresh salad materials.

2. Prepare as much as possible of the company meal.

3. Put the house in order.

4. See that all silver, china, glassware and linen is in perfect condition.

The "Day Of"

1. Set the children at an interesting game early in the day where they will be free to romp. They will then want a rest at your busy time.

2. Think what a joy these guests are to be and how happy you want to make everyone.

3. Do necessary finishing touches, arranging decorations, and rest ten minutes, enjoying your anticipated pleasure before beginning the actual preparation of the meal.

4. Manage a rest period of twenty minutes before dressing for dinner, and call to mind a few amusing incidents to relate.

The ideal hostess is never tired or worried and has a fund of interesting conversation.

"GOOD TASTE TODAY"...

What's correct for spaghetti? Do you know—it's poor form here and in Italy to use both fork *and* spoon? With your fork, cut a few strands into manageable length, then wind them.

What about olive pits? It's natural—and correct—to take pits, seeds or bones from your mouth by thumb and forefinger. *Don't* use napkin as a screen!

How to cope with watermelon. It's easiest to use your fork to dig out pits, then break off small piece at a time. Hold slice in hands only at picnics!

Hold that chop! It won't skid across your plate if you press on the back of your fork correctly with left index finger. What to avoid: Gripping fork like a spear!

Can a knife be used on salad? Only when a hard wedge of lettuce is served. Otherwise the rule is: cut and eat salads with a fork.

Keep your fork down! Don't try to "talk" with your fork. Keep it in your plate when not holding food.

If you should choke on a fish bone, it's perfectly all right to leave the table immediately.

Swimming Cautions

Allow two hours after a meal before you swim. Let your food digest.

In a pool, look to see that the water is cleared of persons in front of the spring-board before you dive.

If you're playing tag in and out of the pool, be careful not to jump on a swimmer. Unless you know the person and are sure he won't mind, don't duck or splash him. He may become distressed or panicky.

Don't dive into unknown water. Make sure it's deep enough, and free of rocks or stumps.

Stay within bounds at a bathing beach. You can have plenty of fun without going beyond the boundary ropes.

Don't ever remain in the water until you've reached the exhaustion point. When you feel yourself getting tired, get out.

Have respect for a river current or an undertow. Most undertows won't bother an experienced swimmer, but they may worry a beginner.

If swimming bothers your ears, wear stoppers.

Don't swim too far under water. You may injure yourself.

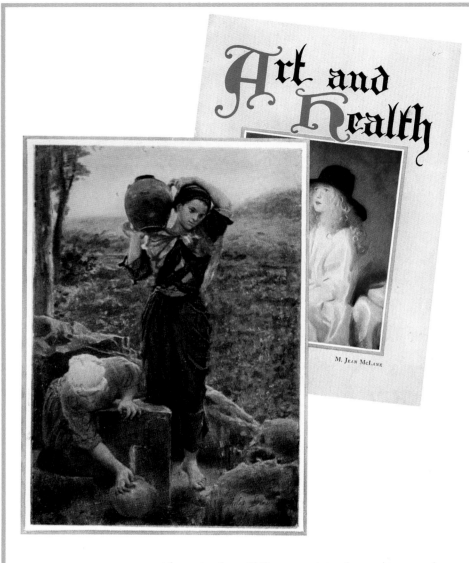

M. JEAN McLANE

THESE young maidens in far-off France visit the spring each
day to fill their jugs with cool, refreshing water.
At least four glasses of water should be drunk each day.

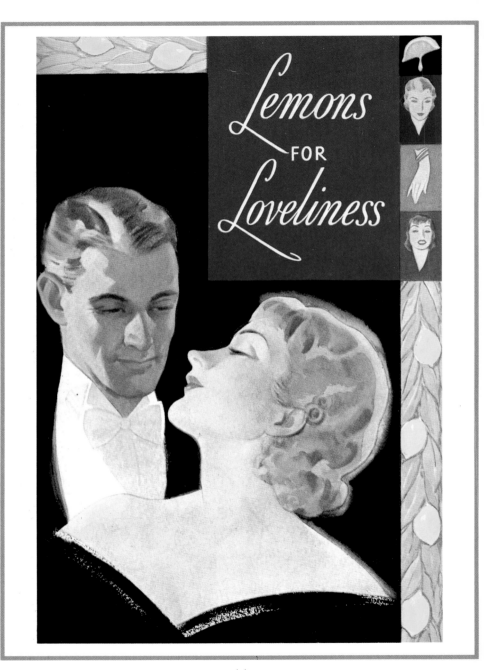

Lemons FOR Loveliness

Keep Them Protected

BEFORE gardening or housework, it is helpful to insert a little white soap under the nails to prevent discoloration. Wear gloves at all times if possible, and after each washing rinse with lemonized water, and apply Lemon Lotion. This is important because the skin of your hands contains fewer oil glands, and therefore dries out more readily.

Keep Beauty Aids in Your Kitchen

IT IS A good idea to keep a bottle of Lemon Lotion in the kitchen as well as in the bathroom. Keep half a lemon in a saucer, cut side down, in your beauty kit, and apply it to the hands immediately after using kitchen soap or cleansing powder. This will neutralize the alkali, remove stains, destroy onion and fish odors.

Keep Them Manicured

BE SURE your hands have a manicure every week. Dip a cotton-tipped orange stick into a cup of warm lemonized water. Your nails will take a better polish when cleaned with lemon juice. Try it.

Make Them Up

DON'T think make-up stops at your face; it works miracles for your hands and arms. Powder them, but always use a powder base first. Just because you don't see your elbows don't think they escape the eyes of others—keep them soft and smooth with Lemon Lotion.

For Your Elbows

IF YOUR elbows are in very bad condition, scrub them in warm soapy water with a bit of pumice stone. One beauty authority suggests placing the elbows in two halves of cut lemons for a few minutes each day.

21

Financial
HOUSEKEEPING

Spending money is every bit as important as making money. Money must be spent in order to live, but if it is spent *wisely*, living can be happier and more comfortable.

Spending money wisely is a wife's duty to her husband and family. But she cannot know how wisely she is spending unless she keeps an accurate record—a budget.

HOW TO BEGIN

You can easily make a practical budget in this way. Take twelve good sized sheets of paper (or buy a big blank book, if you like). Write the names of the months at the top of the sheets. Divide each sheet into seven vertical columns. The first of these columns is for the days of each month. Number in the days, one below the other.

Now number the remaining six columns from left to right and at the top write:

1. Food
2. Shelter (rent or taxes, and upkeep)
3. Clothing
4. Operating (heat, light, phone, furniture, household supplies, automobile, transportation, etc.)
5. Advancement (medical and dental care, education, charity, entertainment and miscellaneous).
6. Savings (in banks, investments or insurance).

HOW TO OPERATE

Each day enter *all* the money spent, under the proper column. That means all the money spent by husband, wife and anyone else in the family. If you pay most of your bills by check this is a fairly easy matter and can be done once a month, except for the "pocket cash" items. If you have no checking account, each person will have to keep a note book or memo.

Your judgment will tell you which columns the various items should go under. Occasionally one is difficult to decide, but try not to make too many "miscellaneous" entries. And be as accurate as you

can. Slips are sure to occur in almost every budget, but too many mistakes will defeat your purpose. At the end of each month total the columns and add together the totals of all columns. That figure should equal your income.

HOW TO SAVE

Of course, it does no particular good just to keep track of expenses. You must use the figures to find out where you are spending too much money and cut it down.

Watch column 5 carefully. This is the place where most waste occurs. Entertainment and miscellaneous items are likely to be too high unless kept in check.

Try, instead, to make column 6 grow. There is a saying that 10% of income should be saved, but with small incomes this cannot be done, and with larger incomes the saving should be greater. In any case, put away money systematically, so much every pay day. That is the real secret of saving.

Economists say that the percentages of income should vary with earnings, about as shown in the table below. It is plain that these percentages will be affected by many circumstances, and cannot be made a hard and fast rule. They are for an average family of four persons.

Kitchen Economies

Dampen stale rolls or muffins and heat them through in the oven. You can hardly tell them from freshly baked.

Potato chips, crackers and flake cereals often get limp and rubbery in damp weather. A few minutes in the oven will restore their original crispness.

If your children refuse to drink milk, buy a package of straws and serve "sodas" in tall glasses. For variety, add a few drops of vanilla. Cold cocoa makes a chocolate soda.

Use up left over berries or fruit as a garnish on your breakfast cereal.

Stale cake makes a good cottage pudding. Cut away all

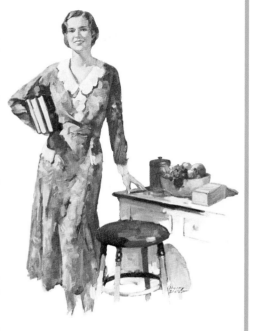

frosting from the cake. Arrange in slices on individual plates and pour hot lemon sauce over it. Top with a bit of jelly.

Cracked eggs need not be thrown away. Use them in cake or custards at once.

Paper doilies and napkins are inexpensive and save laundry. The family will enjoy eating picnic style in summer.

Save gas by filling up your oven. Bake cake, pudding, pies or custards while you are baking potatoes. If you are roasting meat, slip in a pan of apples to bake or an escalloped dish.

Don't throw away the water in which you cook vegetables. Part of the nourishment of the vegetables is in this water. Save it to use in soups and sauces.

HELPFUL "WEIGHING HINTS" TO DIETERS

1. Weigh yourself weekly. Preferably on the same scale, without clothing, and before breakfast. No matter when or where you weigh—try to do it at the same time of day, and with the same weight of clothing.

2. Weekly weighing keeps you *on* the "weight wagon." It helps make dieting easier to *watch* your weight go down. *Don't be discouraged* if you don't start to lose weight immediately. This may be only temporary, due to water retention.

3. Don't follow "fads" when you start to reduce! The "half grapefruit and portion-of-parsley" menu will reduce you— but it may affect your health adversely.

4. Don't depend on exercise to reduce your actual weight. Exercise only tends to make your *muscles* firmer. Remember, it takes a 45-mile hike to lose one pound.

5. Don't try to reduce on a *hurry-up basis*. Remember, it probably took you *years* to put on those extra pounds. It isn't smart to try to lose them overnight.

6. *Don't cheat*—that little bit of extra helping keeps your weight up.

48

THE REDUCING DIET

What woman would not like to be as slender and yet as delicately rounded as these two lovely ladies? It is honestly every woman's wish to be attractive. And, in this age, to be attractive it is also necessary to be slim. Because of this type of figure which all femininity covets, many girls and women have been reducing.

Reducing is a serious matter. It should not be taken lightly. It is not possible to merely cut down on food intake and exist on practically no nourishment without causing harmful results to the body. Reducing diets should be carefully planned to include the essential food elements. A reducing diet should be rich in cellulose, vitamins and minerals as well as having an adequate supply of protein and enough calorie foods to maintain activities.

No doubt you have noticed girls among your own friends whose attractiveness has been hurt rather than improved by a reducing program.

At party fine, I spilt some wine,
 And did my face grow red?
It stained my dress—the table cloth,
 "Don't fret," my hostess said.

"For while it's damp we'll rub it well,
 With ordinary salt,
For that takes out the color stain,
 And leaves no one at fault."

As your omelet gets thicker,
 To keep from being tough,
Just add some boiling water, and
 A little is enough.

If new bread you'd like to cut,
 And not to have it tear,
Just heat your knife 'til slightly warm,
 Smooth slices then are there.

Who hasn't known that awful shock,
 When walking down the street,
To feel a run in stockings silk,
 From tops down to the feet!

To stop those awful, awful runs,
 And add to wearing hours,
Some vinegar put in the rinse,
 And help the stretching powers.

SAFE, Steady *Low* Heat that will not scorch your finest lingerie.

If in clothes hamper comes mildew,
 At seashore, after rain,
Neglected, it will quickly spread—
 Clothes won't look the same.

Get busy when it first is found,
 Rub soap upon the stains,
Then put them out in strong sunlight,
 And soon no spot remains.

QUICK, Steady *High* Heat for heavy, damp linens.

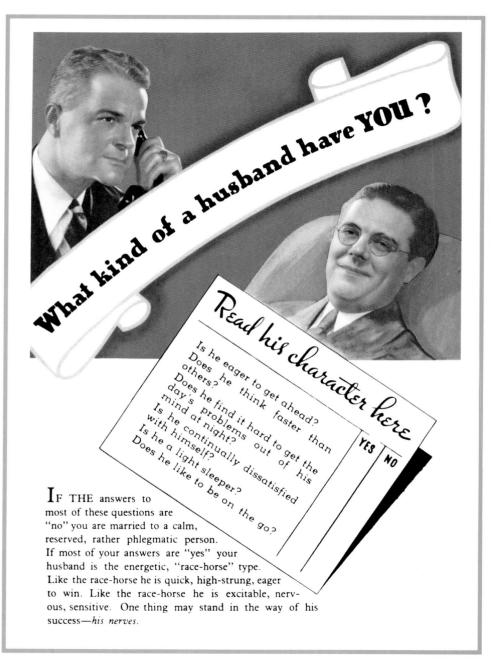

What kind of a husband have YOU?

Read his character here

	YES	NO
Is he eager to get ahead?		
Does he think faster than others?		
Does he find it hard to get the day's problems out of his mind at night?		
Is he continually dissatisfied with himself?		
Is he a light sleeper?		
Does he like to be on the go?		

IF THE answers to most of these questions are "no" you are married to a calm, reserved, rather phlegmatic person. If most of your answers are "yes" your husband is the energetic, "race-horse" type. Like the race-horse he is quick, high-strung, eager to win. Like the race-horse he is excitable, nervous, sensitive. One thing may stand in the way of his success—*his nerves*.

Acknowledgments

Frontispiece
magazine illustration, 1935.
4 magazine illustration, 1921.
6–7 Fish and Seafood Cookery, n.d.
8–9 Bananas . . . how to serve them, 1942.
10 Sunkist Fresh Grapefruit Recipes, n.d. Used with the permission of Sunkist.
11 The Calavo Book of Popular Avocado Recipes, 1949. Courtesy of the Calavo Growers of California.
12 The New Art of Buying, Preserving and Preparing Foods, 1935.
13 The New Method of Cooking, n.d.
14–5 Sunkist Orange Recipes, 1940. Used with the permission of Sunkist.
16–7 Toast Talk, n.d. Recipes On Toast, 1950.
18 Sandwich Surprises, 1929.
19 Recipes and Menus for All Occasions, 1947.
20 The Beech-Nut Book of Menus and Recipes, 1923. Used with the permission of Ralston Purina Co.
21 The Salad Bowl, 1929.
22 How to Care for Your Freezer, 1952. Reprinted courtesy of Sears, Roebuck and Co.
23 New Delights from the Kitchen, n.d.
24–5 Book of Instructions and Recipes, n.d.
26 magazine advertisement, 1930. Used with the permission of Borden, Inc.
27 magazine advertisement, 1940.
28 Everyone Likes Spices, 1939. Used with the permission of Durkee-French Foods.
30–1 How to Cook with Wine, n.d.
32–3 The California Way, 1950.
34–5 Wine is Fun, n.d.
36 Milk For You and Me, 1945.
37 The New Method of Cooking, 1928.
38 The California Way, 1950.
39 Let's Eat Outdoors, n.d.
40 Electric Refrigerator Recipes and Menus, 1927.
41 The Modern Hostess Book, n.d.
42 Swimming and Diving, 1934.
43 Art and Health, 1926.
44–5 Lemons For Loveliness, 1935.
46 The Business of Being A Housewife, 1921.
47 magazine advertisement, 1937. Used with the permission of White Consolidated Industries, Inc.
48 Fish and Seafood Cookery, n.d.
49 A New Way of Living, 1932.
50 magazine illustration, 1924.
51 advertisement, 1948.
Back Cover
 Tempting Recipes for Good Meals, 1941.
Endpapers
 Fabulous Fabrics of the Fifties, copyright 1992.